D1597744

All About Anime and Manga

The Art and Artists of Anime

Bradley Steffens

ReferencePoint Press®

San Diego, CA

RerferencePoint
Press®

About the Author

Bradley Steffens is a novelist, poet, and award-winning author of
more than sixty nonfiction books for children and young adults.

© 2022 ReferencePoint Press, Inc.
Printed in the United States

For more information, contact:
ReferencePoint Press, Inc.
PO Box 27779
San Diego, CA 92198
www.ReferencePointPress.com

LIBRARY OF CONGRESS CATALOGING-IN-PUBLICATION DATA

Names: Steffens, Bradley, 1955- author.
Title: The art and artists of anime / by Bradley Steffens.
Description: San Diego, CA : ReferencePoint Press, 2022. | Series: All
 about anime and manga | Includes bibliographical references and index.
Identifiers: LCCN 2021039412 (print) | LCCN 2021039413 (ebook) | ISBN
 9781678202187 (library binding) | ISBN 9781678202194 (ebook)
Subjects: LCSH: Animated films--Japan--Juvenile literature. | Comic books,
 strips, etc.--Japan--Juvenile literature.
Classification: LCC NC1766.J3 S74 2022 (print) | LCC NC1766.J3 (ebook) |
 DDC 791.43/34--dc23
LC record available at https://lccn.loc.gov/2021039412
LC ebook record available at https://lccn.loc.gov/2021039413

Contents

Global Phenomenon

Since 1915, when records of worldwide box office receipts were first calculated, 106 motion pictures have earned the status of top-grossing movie of the year. The first 105 of these movies—including classics like *Star Wars*, *Titanic*, and *Avatar*—were all made in the United States. In 2020, however, that century-old trend came to an end. The top-grossing motion picture of 2020 did not originate in the United States, China, or any of the world's ten most populous countries. Instead, it came from the world's eleventh-most populous country, Japan. The film is entitled *Demon Slayer: Mugen Train*. Earning more than $474 million worldwide, *Demon Slayer: Mugen Train* was the fifteenth top-grossing movie to be an animated feature, following Disney classics like *Cinderella* (1950), *Aladdin* (1992), and *Frozen* (2013). But *Demon Slayer: Mugen Train* is not like these earlier animated movies. It is darker and more violent, and it is drawn in the style known as anime.

Hallmarks of Anime

The Japanese word *anime* is derived from the English word *animation*, and it originally described any kind of animated work. Outside Japan, *anime* is used to describe an animated film or program that employs certain drawing and animation techniques pioneered in Japan. Anime scenes are often drawn from unusual perspectives—far above or far below—to heighten visual interest. Dramatic close-ups of a character's face are often used to convey emotion.

While anime artists usually draw their characters with realistically proportioned bodies and heads, they often make their characters' eyes exceptionally large. This allows the artists to express a range of emotions quickly and simply. Anime eyes are sometimes rendered in stock ways that express specific emotions: wide open for surprise, half-open for boredom, narrowed for anger, or closed and arched for happy.

The Origins of Anime

Many anime techniques were developed in the 1960s at Mushi Production, an animation studio founded by manga artist and animator Osamu Tezuka. When Tezuka convinced Fuji Television to produce his anime series *Mighty Atom*, he and his small band of animators faced the daunting challenge of producing enough drawings to fill up twenty-five minutes of screen time. Even filming at the relatively slow rate of eight frames per second—one-third the speed that Walt Disney Studios used in its animated films—the animators still had to produce twelve thousand frames' worth of drawings for each episode. Studios such as Walt Disney changed drawings every frame or two to create smooth, realistic motion—a technique known as "full animation." Mushi Production planned to shoot three frames per drawing during movement sequences, but even four thousand drawings was too many for six animators to complete in one week.

To meet its deadlines, Mushi Production turned to a technique known as "limited animation." The goal was to reduce the total

number of drawings to fewer than two thousand per episode. To achieve that goal, Tezuka's team mixed fluid action with moments of holding the camera on one drawing and filming it for several seconds. These holds were not random but supported the storytelling. For example, the camera might hold on a character's face at a dramatic moment to emphasize his or her reaction to something that is done or said. The camera might zoom in on the eyes, without changing drawings, also for dramatic effect. Or the drawings might be changed only slightly, allowing the same drawing to be used for several seconds. For example, a character's eyes might narrow to show concentration or determination, or they might widen to show fear or apprehension. Sometimes, the camera might pan across a single drawing of a landscape to establish a sense of place. Other times, the drawings cut quickly from one character to another, creating the illusion of movement. Employing these techniques, Tezuka reduced the number of new drawings to as few as nine hundred per episode. Although Tezuka employed limited animation to meet his deadlines, his use of

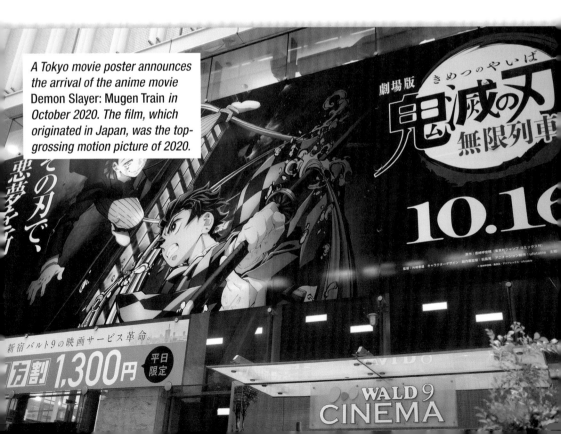

A Tokyo movie poster announces the arrival of the anime movie Demon Slayer: Mugen Train *in October 2020. The film, which originated in Japan, was the top-grossing motion picture of 2020.*

close-ups, pans, zooms, and quick cuts to tell a story and reveal emotions gave his animations a unique look and feel. Tezuka's style was copied and enhanced by other Japanese animators, eventually becoming known as anime.

Once the province of cult audiences, anime has gone mainstream. Media streaming service Netflix says that more than 100 million households around the world watched at least one anime title in the first nine months of 2020, a 50 percent increase from 2019. Antony Traino, a sophomore at Northwestern University in Evanston, Illinois, thinks anime's growing popularity is a good thing: "It's great for people who started watching anime in earnest [years ago]. Back in that time it was not really okay, but now you get a lot more widespread acknowledgement that it's a real art form and not just some fringe media."[1]

"It's great for people who started watching anime in earnest [years ago]. Back in that time it was not really okay, but now you get a lot more widespread acknowledgement that it's a real art form and not just some fringe media."[1]

—Antony Traino, a sophomore at Northwestern University

Chapter One

Osamu Tezuka

On June 22, 1963, a boy robot with rocket engines in his legs zoomed into America's Saturday morning cartoon lineup and captured the hearts of millions. This new animated hero did not look like other cartoon characters at the time. He had dramatically spiked hair and large eyes—even larger than most cartoon characters—with prominent eyelashes and a button nose reminiscent of the 1930s cartoon character Betty Boop. He did not move like other characters, either. He took deliberate steps that lacked the smooth grace of Walt Disney Studios characters. When he listened, his facial expression never changed, except for an occasional blink of the eyes. When he spoke, only his mouth moved. But what mattered to kids was that the little robot, known as Astro Boy, always took the side of good against evil, right against wrong, and fairness against injustice. He had a kind heart. He could not even destroy the larger robots he was forced to fight. The loveable little robot was a television hit.

Although Astro Boy spoke English, the cartoon program did not originate in the United States. It came from Japan. *Astro Boy* was the first Japanese animated program to be broadcast in the United States. The things that made Astro Boy different—his large eyes, spikey hair, and somewhat limited movements—were already influencing other animators in Japan. They were the hallmarks of a new style of animation known as anime.

Aspiring Artist

Astro Boy was the creation of a thirty-five-year-old animator named Osamu Tezuka. Born November 3, 1928, in Osaka, Japan, Tezuka came from a family of educated professionals. His father, Yutaka Tezuka, worked in management at a nearby factory. His grandfather was a lawyer, and his great-grandfather and great-great-grandfather were both doctors.

Tezuka enjoyed drawing from an early age. When he was a toddler, his parents left a notebook and pencil next to his bed so that he could comfort himself if he woke up. He filled so many notebooks with drawings that his mother would erase his work just to create more blank pages for him to use.

When Tezuka was three, his family moved to his grandfather's country house in Takarazuka. His grandfather's law books still filled the library at the home. When there was a shortage of paper during World War II, Tezuka's mother let him fill the margins of the books with his drawings. Drawing in these law books, Tezuka practiced the fundamentals of animation, making slightly different drawings on a series of pages to create the illusion of motion when the pages were viewed in quick succession.

Tezuka's father occasionally brought home Japanese comic books, known as manga, for Tezuka to read. His father also owned a movie projector—a rarity at that time. He often entertained friends and family by showing movies in the home. As a child, Tezuka saw the films of Walt Disney and the Fleisher brothers, the creators of Betty Boop, with his family. He watched the

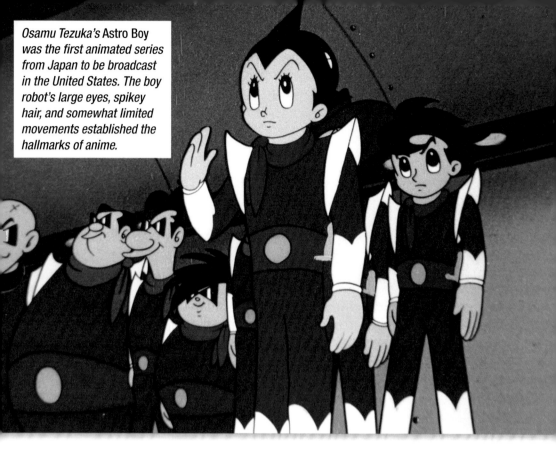

movies dozens of times, carefully observing the backgrounds, the movements of the characters, and their expressions.

At age nine, Tezuka drew his first manga book, *Pin Pin Sei-Chan*. Not only did Tezuka's classmates enjoy the manga, his teachers did, too. Although manga was looked down on by many educated people at the time, Tezuka's teachers encouraged him to keep drawing. By age twelve, Tezuka was using watercolors to create shadows and drawing converging lines to create realistic perspectives in a manga he called *Looking Back Upon Six Years of School Life*.

Drawn to the Medical Profession

When Tezuka was sixteen, he contracted ringworm, a fungal infection. His arms became so swollen that a doctor told his mother he would have had to amputate the boy's arms if she had waited a few more days to bring her son to the hospital. Terrified that

he might never draw again, Tezuka followed his doctor's treatment regimen exactly, even keeping his arms above the level of his heart at all times. He recovered, but the experience gave his life direction. He decided to become a doctor so he could help people the way he had been helped.

While Tezuka was preparing to enroll in medical school, a friend of the family who worked at the newspaper and was familiar with Tezuka's drawings thought the teenager could draw a planned, four-panel comic strip about a mischievous student named Ma-chan. Upon the friend's recommendation, Tezuka got the job. The strip, *Diary of Ma-chan*, debuted on New Year's Day 1946. It became so popular that the publisher created a simple wooden Ma-chan doll with movable arms and legs to sell to the public. Although Tezuka did not receive royalties from sales of the doll, he was thrilled to see children playing with a toy made in the likeness of a character he had drawn.

Buoyed by his success, Tezuka approached the magazine *Hello Manga* with a story titled *Yamabiko*. The editor, an author and screenplay writer named Shichima Sakai, accepted Tezuka's story, and it debuted in October 1946. Sakai was so impressed with Tezuka that he asked the young artist if he would turn his story, *New Treasure Island*, into a book-length manga. To sustain visual interest in a book-length comic, Tezuka drew on his knowledge of visual techniques used in the motion pictures he had watched at home and in movie theaters as he grew up. These techniques included panning, zooming, close-ups, and forced perspectives. The book was a hit, selling more than four hundred thousand copies.

Tezuka continued to draw manga even after he entered medical school. In his free time he traveled to Tokyo to show his work to the largest manga publishers. For three years Tezuka presented his work without success. Then in April 1950, in his last year of medical school, Tezuka met with Kenichi Kato, the editor of *Manga Shōnen*. Tezuka showed Kato a full-length book titled *Jungle Emperor*, a story about a lion cub named Leo. Kato liked the

A Fascination with Insects

As a child, Osamu Tezuka was fascinated by insects. He spent countless hours watching ants, butterflies, and beetles around the family home in Takarazuka. In middle school Tezuka began collecting insects, mounting them in display cases, and learning their scientific names. He and a classmate founded an insect study club. Inspired by the illustrations in a book by a famous entomologist, Tezuka began drawing insects in precise detail. He wrote and illustrated eleven issues of the club's publication *The World of Insects* in 1944. Tezuka also began to incorporate insects into his comics, including a manga titled *The Story of Detective Mamar*.

Tezuka was greatly interested in beetles, especially a fast-running predatory beetle known as the bombardier beetle, or stink bug. The Japanese name for the beetle family, Osamushi, is similar to Tezuka's first name, Osamu. Delighted by the coincidence, Tezuka started adding a Japanese character to his signature, changing it from Osamu to Osamushi. A wearer of eyeglasses, Tezuka added two dots to the squares in the characters for "mushi" to look like eyes in eyeglasses. Later, Tezuka named his animation studio, Mushi Production, after this figure and incorporated the eyeglass motif into the company's logo.

story, but for it to run in his monthly magazine, he said, it would need to be broken into a series. Tezuka agreed to adapt the story to the serial format. The first installment of *Jungle Emperor* ran in October 1950. Popular among manga readers, the series ran for five years.

A Major Decision

While enjoying success as a *mangaka* (the Japanese term for manga artists), Tezuka kept his focus on his medical studies, graduating with a medical degree in April 1951. He then faced his first major decision as an adult: whether to become a doctor or a full-time artist. He received advice from many people, but in

the end his mother's advice proved most important. She told him to ignore what other people said and listen to his heart. Although Tezuka loved the idea of helping the sick, he knew that his true passion was telling stories in words and pictures. In 1952, at age twenty-four, Tezuka moved to Tokyo and settled into his career as a mangaka.

Shortly after deciding on his career, Tezuka sold a new monthly serial to *Shōnen Club*. Titled *Ambassador Atom*, it tells the story of an invasion of Earth in 2003 by millions of humanoids from a parallel world that was destroyed thousands of years before. At first, the human beings welcome the alien visitors, but the sudden increase in Earth's population creates difficulties, including overcrowding and food shortages. Tensions rise, and war is imminent until a scientist creates a childlike robot that turns out to be a skilled mediator, resolving conflicts and forging peace between the humans and aliens. The robot, known as Ambassador Atom, looks and acts like a schoolboy. The childlike peacemaker proved immensely popular with young readers, who flooded the publisher with fan letters.

After a year of success with *Ambassador Atom*, Tezuka's editor, Takeshi Kanai, suggested that the young artist create a series around the popular character. Knowing that emotion is vital to the believability and popularity of a character, Tezuka wondered if he could build a series around a robot. "At first he was completely doll-like," Tezuka remembered. "He had no personality, no feelings, and he acted as a silly robot foil for the other characters in the story."[2] Kanai understood the problem, but he believed the young artist could overcome it. "Make him a robot with a human personality," said Kanai. "Then the readers will identify with him, and think of him as a friend. Instead of making him

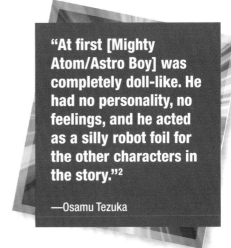

"At first [Mighty Atom/Astro Boy] was completely doll-like. He had no personality, no feelings, and he acted as a silly robot foil for the other characters in the story."[2]

—Osamu Tezuka

a character that takes off his head and arms for a gag, make him a robot with emotions, who laughs, cries, and gets angry when he senses injustice."[3]

Tezuka took on the assignment and created what would become one of his most beloved characters, Mighty Atom, known outside Japan as Astro Boy. He gave the robot a backstory, telling how a mad scientist named Dr. Tenma created the robot to take the place of his son, who had recently died in an automobile accident. When the robot does not grow like a boy, Tenma sells him to a circus, where he is given the name Atom and forced to fight other robots in gladiator-like spectacles. There he is spotted by Professor Ochanomizu, a robot enthusiast from the Ministry of Science. Ochanomizu frees Atom from the circus and becomes his surrogate father, enrolling the boyish robot in school and teaching him about the world. The series debuted in 1952 as *Mighty Atom*, and it quickly gained a following. Installments appeared in every monthly issue of *Shōnen Club* until 1968, when the magazine went out of business. Even then, the popular series continued in the *Sankei* newspaper, the *Tetsuwan Atomu Fan Club Magazine*, and other outlets.

From Page to Screen

As Japan recovered from the devastation of World War II, programs were needed for the new and growing medium of television. In 1957, at the height of *Mighty Atom*'s popularity, Tokyo TV broadcast a "paper-play" version of *Mighty Atom*, showing panels from the popular manga while a narrator read the story. In 1959 Fuji Television contracted with Tezuka to produce a live-action series based on *Mighty Atom*. Wearing a helmet and plastic body armor, actor Masato Segawa played the role of the titular robot. As Tezuka watched his characters come alive on television screens, he decided it would be a good time to try his hand at animation. He teamed up with the animation studio Tōei Dōga in 1960 to bring his manga story *Boku no Songokū* (My Monkey King) to the screen as a full-color movie titled *Saiyūki* (Alakazam

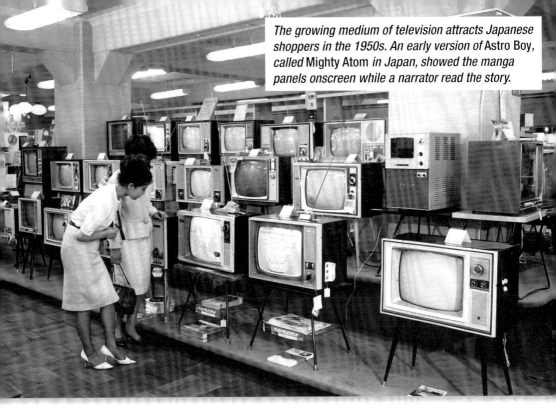

the Great). Although he gained valuable experience during the project, Tezuka became frustrated with the way the Tōei Dōga was run. In 1961 he founded his own animation studio, Mushi Production.

Tezuka's first production was *Story of a Certain Street Corner*, a thirty-eight-minute, full-color movie for adults with an anti-war theme. The movie was designed to demonstrate the studio's capabilities to potential clients who might want to use animation to promote their products and to television and movie producers looking for sources of new material. As the six members of the studio worked on the movie, one of the animators, Yusaku Sakamoto, suggested turning Tezuka's popular manga *Mighty Atom* into an animated television series as a way of quickly earning money. "[Tezuka] must have been thinking along the same lines," Sakamoto later recalled, "because he immediately said, 'Let's do it.'"[4]

In November 1962 Mushi Production held a private screening of *Story of a Certain Street Corner* plus a ten-minute episode of *Mighty Atom*. Fuji Television was impressed enough by the pilot

A Message for the Future

Shortly before his death, Osamu Tezuka wrote a book titled *Save Mother Earth: To the Youth of the Twenty-First Century*. It includes wisdom Tezuka wished to pass on to future generations. Passages from the book are excerpted here:

> Humans and other life forms are completely equal as living things; my interpretation of the existence of human beings is that they represent just one part of a whole community of beings brought together by fate. . . .
>
> Humans are just barely a new form of existence in the earth's history. Yet, now we consider ourselves to be the lords of creation, thinking that everything is ours, and we continue to wreak havoc on the natural world in whatever way we wish, and to kill the animals en masse. We have come to the point where we must think very seriously about what is really important, and what is really necessary: we have come down to our last chance. . . .
>
> Even when faced with the ugliest truth, mankind has the power to change circumstances that seem virtually impossible to fix. . . .
>
> Our imagination may be the most brilliant of all energy that humans have ever possessed.

Osamu Tezuka, "Message for Earth," Tezuka Osamu Official Website, 2021. https://tezukaosamu.net.

of *Mighty Atom* to order five episodes of the new show. It was the first animated television series ever to be produced in Japan. The first episode aired January 1, 1963. An astounding 27 percent of all viewers in that time slot tuned in to watch "The Birth of Mighty Atom." Ratings remained high, and Fuji Television ordered a full season's worth of episodes. The series continued until December 31, 1966, with the lovable little android entertaining viewers through 193 episodes. The eighty-fourth episode, "Dolphin Civili-

zation," broadcast on August 29, 1964, was watched by 40 percent of all viewers—a ratings record that still stands.

To meet the demands of a twenty-five-minute broadcast, Tezuka and his six animators had to create at least four thousand drawings, but that was too many for the small staff to create in a week. Tezuka's team pioneered new "limited animation" techniques to reduce the number of drawings to less than two thousand. For example, when someone talked, the drawing might stay the same, with only the lips moving. Or the camera might hold on a drawing of the person listening, with only their eyes blinking from time to time. Each hold could use up dozens of frames of film. What Tezuka did not realize at first was that such holds often increased the drama of certain scenes for the audience.

Breaking Into the US Market

The ratings success of *Mighty Atom* attracted the attention of a talent agent in Tokyo who was planning a trip to New York. He asked Mushi Production for a print of *Mighty Atom* that he could shop around to television networks in the United States. Tezuka agreed, and in March 1963 the agent showed the new show to executives at NBC. Fred Ladd, a producer who specialized in dubbing and reediting foreign cartoons for American audiences, was charmed by the boy robot but shocked by the animation style. "Man, that was LIMITED animation run amuck!"[5] he observed. Ladd turned the first and third episodes of *Mighty Atom* into English-language pilots, and NBC bought the series.

> "Man, that was LIMITED animation run amuck!"[5]
>
> —Fred Ladd, NBC executive

Believing the word *atom* had too many negative connotations—atom bomb, atomic radiation, atomic warfare—Ladd and NBC executive Bill Breen renamed the character Astro Boy after the newly coined term for the pilot of a rocket ship—astronaut. The name stuck, and the series, which debuted in

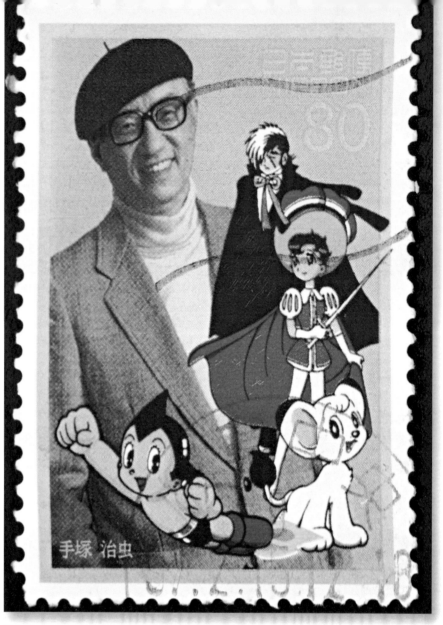

The Japanese postal service celebrated Osamu Tezuka's many accomplishments in anime with a stamp that featured the artist and several of his most beloved characters.

1964, was named *Astro Boy*. Likewise, subsequent television series released in 1980 and 2003, a feature film released in 2009, video games, and the English-language translations of the *Mighty Atom* manga books all used the name *Astro Boy*. The popular robot has inspired a host of merchandise, including dolls, action figures, trading cards, stamps, apparel, and even foods. The fi-

nancial analyst firm Berkshire Hathaway estimates that sales of Astro Boy merchandise exceed $3 billion worldwide.

Global Success

The infusion of cash from the NBC deal allowed Mushi Production to hire more staff and pursue a host of new ventures, including new television series and feature films. In 1965 Tezuka adapted his *Jungle Emperor* manga series into an animated program that became known around the world as *Kimba the White Lion*. Other major series include *Adventures of the Monkey King* and *Princess Knight*. The studio also provided animation for *Frosty the Snowman*, which debuted on CBS on December 7, 1969, and has aired during the holiday season every year since.

Mushi Production continued to grow over the years, eventually employing a staff of four hundred people. The company produced ten television series, fourteen television specials, and ten motion pictures based on Tezuka's work. It also made ten television series, twenty-three theatrical films, and eight direct-to-video movies based on material not created by Tezuka.

In 1988 Tezuka was hospitalized with stomach cancer and underwent two surgeries. He continued to draw while in the hospital, working on a story about composer Ludwig van Beethoven and his third adaptation of Johann Wolfgang von Goethe's 1808 play, *Faust*. At one point a nurse tried to take away Tezuka's drawing materials so he could rest. "Please, please," he begged the nurse, "let me continue to work."[6] According to his wife, Etsuko, those were the last words Tezuka spoke. He died on February 9, 1989. By then Tezuka had earned the honorific title "God of Manga" for having produced more than seven hundred volumes of graphic literature, including his award-winning adult series *Black Jack*, *Buddha*, and *Phoenix*. Tezuka considered *Phoenix*, a story about life, death, and immortality, to be his masterpiece. He worked on it from 1954 to 1988, and it was still unfinished at his death.

Chapter Two

Hayao Miyazaki

In the last month of World War II, with Japan's air defenses crumbling, Allied bombers struck deep into the heart of Japan's main island, Honshu, firebombing the city of Utsunomiya. On the ground, thousands of families rushed to escape the inferno. Among them was the Miyazaki family—Katsuji Miyazaki, an aeronautical engineer who ran Miyazaki Airplane, a company that manufactured parts for airplanes; his wife, Dola; and their children, Arata, Hayao, and Yutaka. Katsuji Miyazaki's brother picked up the family in a truck to drive them to safety. The Miyazakis rode in the back, covering themselves with blankets to shield them from sparks and ash from the burning buildings. Hayao, who was only four at the time, heard a woman's voice pleading with his parents for help. "It was a woman carrying a little girl, someone from the neighborhood running toward us saying, 'Please let us on.' But the car just kept on going. And the voice saying, 'Please let us on' got farther away and it gradually took root in my head the way a traumatic event does."[7]

Haunted by Powerlessness

As an adult, Miyazaki often thinks about the mother and child that the family left behind. He not only wishes his family had helped the woman, he regrets not doing something himself. "If I had been a parent and been told by my child to stop, I think I would have stopped," Miyazaki says. "There are plenty of reasons why you couldn't do that . . . but I still think how much better it would have been if I had told them to stop."[8] Miyazaki's memories of that night—the horror of the attack on civilians, his family's refusal to help the young woman, and his own inability to make a difference in a life-or-death situation—have haunted Miyazaki throughout his life as an anime artist. In one film after another, Miyazaki would rewrite his childhood experience, creating young heroes who have the courage and determination to help others even in dire situations.

Hayao Miyazaki was born on January 5, 1941, in the town of Akebono-cho, located in the Bunkyō ward of Tokyo. When he was three years old, the Miyazaki family relocated to his paternal grandfather's estate in Utsunomiya. His grandfather's estate had a 2-acre (8,093 sq. m) garden with a greenhouse and fish pond—a tranquil place in which the Miyazaki brothers escaped into a world of their own. Although the tranquility would eventually be shattered by war, throughout his career, Miyazaki would create enchanting gardens where his characters could retreat from the world.

A Drawing Prodigy

Although Miyazaki would later feel guilt over the role the family business played in the war effort, he was fascinated by aircraft as a child. He spent countless hours drawing airplanes, tanks, battleships, and other machines of war. He was also a keen observer of buildings and landscapes, and he could render them with precision. According to Arata, the brothers entered an elementary school art contest with drawings of their grandfather's garden as

seen from a second-story window of their house. Although Hayao was two years younger than Arata, his drawing was better. In fact, Arata says that when the judges came to Hayao's drawing, they could not believe it had been done by a student. Suspecting that an adult had helped Hayao, the judges awarded first prize to Arata.

With his drafting skills, Hayao Miyazaki could have pursued a career doing architectural, engineering, or other technical drawings, but two events turned him toward a career in the arts. One was his encounter with manga art, especially the work of Osamu Tezuka. "I liked his manga the best of all the ones I read," Miyazaki says. "The tragedies in his manga during the 1940s and 1950s—the early atomic era—were scary enough to make even a child shudder, they were so appalling."[9]

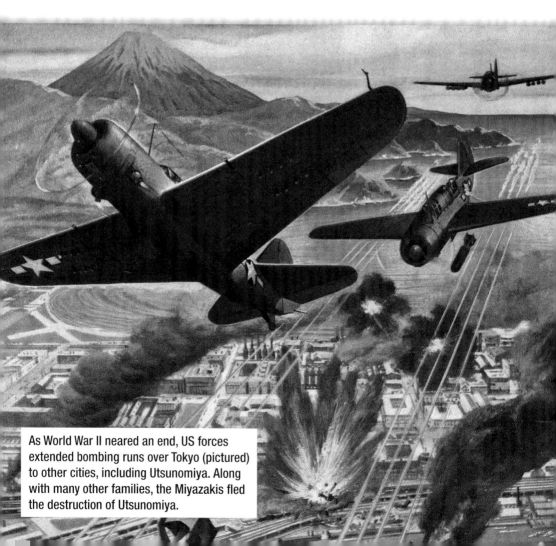

As World War II neared an end, US forces extended bombing runs over Tokyo (pictured) to other cities, including Utsunomiya. Along with many other families, the Miyazakis fled the destruction of Utsunomiya.

Inspired by Tezuka, Miyazaki began creating manga stories of his own. He remained fascinated by manga even as his friends were turning away from it. "I was probably the only guy I knew in high school who actually read manga," Miyazaki remembers. "If I'd told people then that I also drew comics, they would've treated me as though I were an idiot. I had an alibi ready, of course, so it was easy for me, because at the time I thought that anyone who didn't appreciate the potential of manga has to be an idiot."[10]

Moved by Film

As a teen, Miyazaki became captivated by *gekiga* manga—dark, cynical stories that never have happy endings. That is when the second life-changing event occurred. When Miyazaki was seventeen, he went to see *Hakujaden* (*Tale of the White Serpent*), Japan's first full-length color animated movie. The film touched Miyazaki's heart and shook him out of his cynical pose. He remembers:

> I fell in love with the heroine of this animated film. I was moved to the depths of my soul and—with snow starting to fall on the street—staggered home. After seeing the dedication and earnestness of the heroine, I felt awkward and pathetic, and I spent the entire evening hunched over the . . . table, weeping. . . .

> At the time I dreamed of becoming a manga artist, and I was trying to draw in the absurd style then popular, but *Hakujaden* made me realize how stupid I was. It made me realize that, behind a façade of cynical pronouncements, in actuality I really was in love with the pure, earnest world of the film. . . . I was no longer able to deny the fact that there was another me—a me that yearned desperately to affirm the world rather than negate it.[11]

Still planning to become a manga artist, Miyazaki kept his ambitions to himself after graduating from high school. Instead of

enrolling in an art or design program in college, Miyazaki studied economics and political science. He later said that economics was the field of study that offered him the most free time to draw, since most of the courses required students only to write a term paper at the end of the semester. Nevertheless, Miyazaki realized he could not progress as an artist completely on his own. He sought out his middle school art teacher as a mentor. He spent many hours in the older man's studio, working on his manga and talking about art.

A Singular Imagination

By the time Miyazaki graduated from college, he was ready to reveal his true ambitions. In 1963, at age twenty-two, he applied for a job as an animator at Tōei Animation, Japan's largest animation studio. The company required the applicants to sketch pictures that showed movement. Miyazaki aced the drawings and was hired as an in-betweener. This artist draws the animation cels between one pose and another, creating the illusion of smooth movement between the two points. Since the main poses are created by other animators, the in-betweener simply copies the other drawings and makes small changes to them. Although requiring little creativity, the job was perfect for Miyazaki, who had trouble drawing people. By copying the drawings of the other animators, Mi-

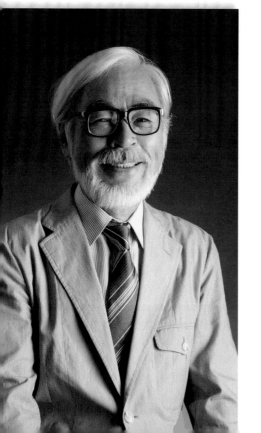

The devastation of war, the dangers of technology, and the costs of environmental damage are common themes in Hayao Miyazaki's work. In a 2009 interview, Miyazaki (pictured the year before) described young people becoming independent as another theme in his anime.

The art and artists of anime /

31318057664103

p10353768

Please check out item.

Sat Apr 30

2327 J

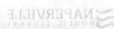

Miyazaki's Masterpiece

Many people consider Miyazaki's 2001 film *Spirited Away* to be his masterpiece. It tells the story of a ten-year-old girl named Chihiro who enters the realm of the *kami*, the supernatural beings of the Shinto religion, so she can find a way to undo a spell that has turned her parents into pigs. At the 75th Academy Awards, *Spirited Away* became the first foreign film to receive an Oscar for Best Animated Feature. In 2017 the *New York Times* ranked *Spirited Away* number two on its list of The 25 Best Films of the 21st Century So Far. Writing for the *New York Times*, film director Guillermo del Toro observed:

> In "Spirited Away" you have a girl right at the threshold of becoming a young woman and leaving her childhood behind, figuratively and literally. . . . There's a beautiful, very melancholic meditation—the same melancholy that permeates all Miyazaki's films. . . .
>
> There is a moment in which beauty moves you in a way that is impossible to describe. It's not that it's a fabrication, it's that it's an artistic act and you know nothing you will encounter in the natural world will be that pure. Miyazaki has that power.

Quoted in Manohla Dargis and A.O. Scott, "The 25 Best Films of the 21st Century So Far," *New York Times*, June 9, 2017. www.nytimes.com.

yazaki became proficient at drawing figures, faces, and all types of movements, so much so that he later said, "My real schooling was at Tōei Animation."[12]

Even as Miyazaki performed the studio's grunt work, he maintained his creative spark. As he and other animators worked toward the end of *Gulliver's Travels Beyond the Moon*, a science fiction film featuring a war between two robot armies, Miyazaki had an idea—one so good that he could not keep it to himself. Even though he had only been on the job a few months, Miyazaki went to the writers and director with a suggestion: what if, at the end,

when Gulliver rescues the good princess robot, her metallic shell opened to reveal a live girl inside? Everyone realized that this small change in the animation would have a huge impact on the meaning of the movie. It would mean Gulliver had not just saved the robot princess, he had freed her and her robot army from their metallic shells, returning them to their human forms. The director approved the idea, and the new ending was put on film. Miyazaki's colleague, Yōichi Kotabe, remembers how he felt when he saw the movie: "I was shocked when I saw how he had changed the scene. The difference was amazing. From something inorganic emerges a real human being, and for an instant the wind flutters her hair. That was really something never done before. We thought 'Wow!' when it turned out that it was Hayao Miyazaki who had thought it up."[13]

Although Miyazaki did not receive recognition for his idea in the film credits, he earned the respect of everyone at the studio. Even more importantly, he gained confidence in his own creative abilities. He knew he could make a good movie of his own if he got the chance.

Important Promotions

Miyazaki continued to work as an in-between for two years, all the time improving his drawing skills. In 1965 he was promoted to animator for a new television series, *Hustle Punch*, about a bear named Punch. Now he was providing the key animation drawings, and the in-betweeners were connecting them for him. After proving his skill in that twenty-six-episode series, Miyazaki served as animator for a series called *Rainbow Warrior Robin*, about a group of warriors who defend Earth from alien attack.

That same year, Miyazaki married Akemi Ota, a fellow animator at Tōei Animation. They would go on to have two sons, Gorō, born in 1967, and Keisuke, born in 1969. The couple has remained married for more than fifty-five years.

Having proved himself in television, Miyazaki was tapped to work on a feature-length film, *The Great Adventure of Horus, Prince of the Sun*, which tells the story of a young Norse hero named

Miyazaki Contemplates His Future

Sixteen months after Hayao Miyazaki announced his retirement, documentary filmmaker Kaku Arakawa began filming Miyazaki as he worked on the animated short *Boro the Caterpillar*. In the film, Miyazaki contemplates coming out of retirement to make another feature-length movie:

> Self-satisfied people are boring. We have to push hard and surpass ourselves.
>
> I'm a retired old geezer. A pensioner. I've got things I want to do, but I don't feel I can. I want to create something extraordinary. I just don't know if I can do it. . . .
>
> All old directors say they'd rather make films than do anything else. But I don't want to make crap. I want to go somewhere new. For me, it's not about the story. One shot tells me whether a film's great or not. That's the essence of film. . . .
>
> We never thought our films would be popular. We accepted that. We just made what we wanted. But that's why we survived. If we'd tried to please, we'd be long forgotten. . . .
>
> Being the work of a retiree, it'll have to feel like it had to be made. It'll be something new. A place I'd never been before.

Quoted in Arakawa Kaku, director, *Never-Ending Man: Hayao Miyazaki*, trans. David Crandall. Tokyo: NHK, 2017.

Horus who battles the ice devil Grunwald. Although only twenty-four, Miyazaki played a major role in the development of the film, serving not only as a chief animator but also as a concept artist and scene designer. The film was directed by Isao Takahata, who had directed several television series for Tōei Animation. It was the first film Takahata directed, and it marked the beginning of a collaboration with Miyazaki that would continue for the rest of their lives.

For three years Miyazaki and Takahata labored to bring the story to the screen. The movie opened in July 1968. It was not a financial success, but film critics loved it. A critic for the Japanese magazine *Taiyo* wrote, "In one corner of the world there now exists a commercial animation that has surpassed Disney and started to make rapid advances."[14]

Miyazaki worked on four more movies for Tōei Animation: *Puss in Boots*, *The Flying Ghost Ship*, *Animal Treasure Island*, and *Ali Baba and the 40 Thieves*. In 1971 Miyazaki and Takahata moved to A Production, or A-Pro, a rival studio, where they worked on the television series *Lupin III*. Two years later, Miyazaki and Takahata left A-Pro and joined Zuiyo Pictures. There they worked on the television series *Alpine Girl Heidi*, *Future Boy Conan*, and *Anne of Green Gables*.

A Chance to Direct

Halfway through *Anne of Green Gables*, Miyazaki received the opportunity he had been working toward for fifteen years. In early 1979, a Tokyo animation studio recruited him to cowrite, storyboard, and direct his first feature film, *Lupine III: The Castle of Cagliostro*. Although the characters and story were not his own, he was in charge of bringing the tale to the big screen. Under Miyazaki's direction, the team of animators completed the film in just seven months. It opened in December 1979 to excellent reviews. *Film Comment* critic Nicole Armour noted Miyazaki's mastery of the medium. "Hayao's attention to detail is astonishing, most notably in the Count's castle, a maze of tunnels, towers and detours, where fight scenes carry us from its rooftops to its elaborate duct system, all executed with cunning."[15]

Having established himself as an animation star, Miyazaki spent the next few years working on a freelance basis for different studios. Between film and television projects, he worked on his own manga series, *Nausicaä of the Valley of the Wind*, which follows the adventures of Nausicaä, a young princess who lives one thousand years in the future, after the industrial world has self-destructed and left behind a polluted earth. Carried in *Animage*, a monthly entertainment magazine, *Nausicaä of the Valley of*

the Wind found a loyal audience, running from February 1982 to March 1994. Collections of the manga series, known as *tankōbon* volumes, have sold more than 17 million copies worldwide.

Bringing His Vision to the Screen

Two years after the manga series began, Miyazaki's publisher suggested turning *Nausicaä of the Valley of the Wind* into a movie. Released on March 11, 1984, *Nausicaä of the Valley of the Wind* was Miyazaki's first film based on his own concept, characters, and story line. It featured themes that grew out of Miyazaki's childhood memories of World War II, including the devastation of war, the dangers of technology, and the costs of environmental damage. It also featured the first in a line of strong, female main characters. In fact, preteen and teenage heroines would be the main characters in six of Miyazaki's next eight films, a departure from most anime films of the time, earning Miyazaki a reputation as a champion of gender equality. For his part, Miyazaki sees his themes of personal independence extending to all young people, as he explained in a 2009 interview:

"I had another idea, and that was to create manga for the children of the world that said, "Kids, don't be stifled by your parents," and, "Become independent from your parents." With that as my starting point, I have spent the last twenty years trying to do this."[16]

—Hayao Miyazaki

I realized that I should depict the honesty and goodness of children in my work. But parents are apt to stamp out their children's purity and goodness. I had another idea, and that was to create manga for the children of the world that said, "Kids, don't be stifled by your parents," and, "Become independent from your parents." With that as my starting point, I have spent the last twenty years trying to do this.[16]

Supported by the fan base of the manga series, *Nausicaä of the Valley of the Wind* was a financial success, earning about $14 million in Japanese theaters and even more in global distribution.

Studio Ghibli

Buoyed by the success of *Nausicaä of the Valley of the Wind*, Miyazaki teamed up with Takahata and producer Toshio Suzuki, who had also worked on *Nausicaä*, to found their own animation company, Studio Ghibli. Over the next thirty-five years, Studio Ghibli would release twenty-three feature films, including nine written and directed by Miyazaki: *Castle in the Sky* (1985), *My Neighbor Totoro* (1988), *Kiki's Delivery Service* (1989), *Porco Rosso* (1992), *Princess Mononoke* (1997), *Spirited Away* (2001), *Howl's Moving Castle* (2004), *Ponyo* (2008), and *The Wind Ris-*

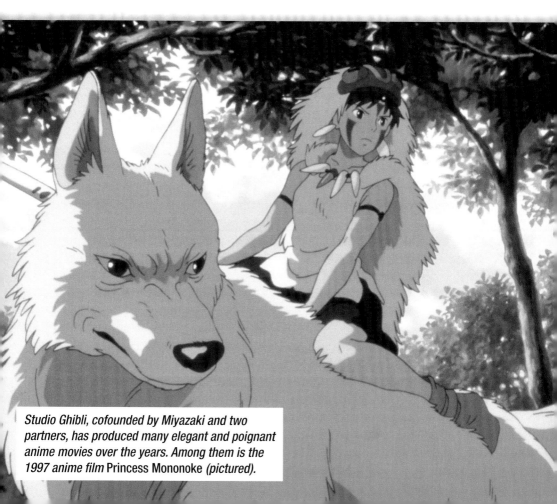

Studio Ghibli, cofounded by Miyazaki and two partners, has produced many elegant and poignant anime movies over the years. Among them is the 1997 anime film Princess Mononoke *(pictured).*

es (2013). Takahata has written and directed four feature films, and Miyazaki's son, Gorō, has written three and directed one. Nine Studio Ghibli films, including five written and directed by Miyazaki, have been the highest-grossing films of the year in Japan. In addition, the studio has produced twenty-five short films, an anime television series, several documentaries, numerous commercials, and five video games.

> "It's boring to do nothing. It's as simple as that. . . . I'm prepared to die before it's finished. I'd rather die that way than die while doing nothing. To die with something to live for."[17]
>
> —Hayao Miyazaki

In 2013, at age seventy-two, Miyazaki announced that he was retiring from the making of feature films. He said he would devote himself to smaller projects for the Studio Ghibli Museum, which had opened in Mitaka, a city on the western edge of Tokyo, in 2001. One of the smaller projects was an animated short to be shown only at the museum: *Boro the Caterpillar*. During the making of this short, which was released in 2018, Miyazaki got the idea to make another feature film. Despite misgivings about his age and his ability to concentrate, Miyazaki decided to go forward with the project. "It's boring to do nothing. It's as simple as that," he says. "I'm prepared to die before it's finished. I'd rather die that way than die while doing nothing. To die with something to live for."[17] That movie, *How Do You Live?*, is scheduled for release in 2023.

Hajime Isayama

In February 2021 Parrot Analytics, a company that measures audience demand for media content, reported something unusual. For the week of January 31 to February 6, the television program in greatest demand across all platforms in the United States was not a live-action show like ratings giants *The Mandalorian*, *Stranger Things*, or *The Witcher*, and it was not made in the United States. It was the Japanese anime series *Attack on Titan*. The program had 110.5 times the demand of the average television series—a figure 40 percent higher than 2020's top-rated show, *The Mandalorian*, which had 65.7 times the demand of the average show. It was the third week in a row that the anime series was the most in-demand program in the United States.

A Humble Star
Attack on Titan is set at a time in the future in which the remnants of the human race live in a city surrounded by three enormous walls that protect them

from gigantic man-eating human-oids referred to as titans. The main character, Eren Yeager, vows to exterminate the outsized beings after one of them destroys his hometown and kills his mother.

The apocalyptic story is the creation of Hajime Isayama, a Japanese artist who is known for his storytelling genius and his personal humility. Even though Isayama is the creator of the hit series, he asks his animation staff not to refer to him by the traditional title of sensei, or teacher.

> "I think *Attack on Titan* came from the experience growing up in a farm. As a child, I remember thinking all living creatures must get nutrition from other living creatures to survive. We might call it cruel, but it is actually the norm."[19]
>
> —Hajime Isayama

"Basically, I started from a place where I wasn't worthy of drawing manga," Isayama explains. "That's why I feel that the people who are helping me are also teaching me, or that I am getting better at my work. I didn't think I was in a position like a teacher."[18]

Isayama's humility and traditional values were instilled in him by his parents, Mitsuo and Emi Isayama, who own a farm in Ōita Prefecture on the island of Kyūshū, 495 miles (797 km) southwest of Tokyo. Born August 29, 1986, Isayama helped out on the farm in his youth, an experience that he believes shaped his imaginary world. "I think *Attack on Titan* came from the experience growing up in a farm," Isayama told BBC News. "As a child, I remember thinking all living creatures must get nutrition from other living creatures to survive. We might call it cruel, but it is actually the norm."[19]

A Love of Monsters

Like many children, Isayama loved dinosaurs. He spent countless hours drawing the giant beasts, and he dreamed about spending his life around them. When his parents asked him what he wanted to do when he grew up, Isayama said he wanted to be a security guard at a dinosaur museum.

The young Isayama was fascinated by the motion picture *Jurassic Park*, which tells the story of carnivorous dinosaurs that escape from captivity and terrorize human beings. In one scene, a *Tyrannosaurus rex* attacks and devours a human being. "There are some factors which influenced me to make *Attack on Titan*," says Isayama. "One would be *Jurassic Park*: being eaten by a huge thing."[20]

Another factor that shaped his popular anime series is a video game Isayama played as a teenager. "I got the idea for *Attack on Titan* from a computer game," Isayama explains. "The whole universe was under attack from aliens. I thought if those monsters ate humans, that would be pretty interesting—the cruelty of man-eating titans."[21]

A final element in Isayama's imaginary mash-up came from *Jigoku Sensei Nūbū*, a manga series written by Shō Makura and illustrated by Takeshi Okano. One chapter features a man-eating character named Mona Lisa. "This man-eater eats with human

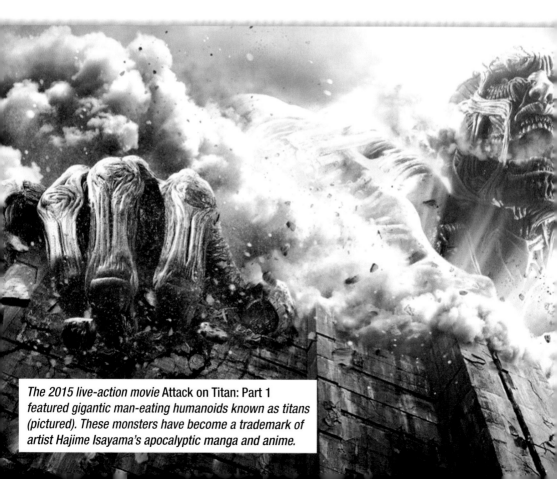

The 2015 live-action movie Attack on Titan: Part 1 *featured gigantic man-eating humanoids known as titans (pictured). These monsters have become a trademark of artist Hajime Isayama's apocalyptic manga and anime.*

teeth, not sharp animal teeth, and it looks super harsh,"[22] says Isayama. Inspired by Okano's drawings, Isayama would go on to create terrifying creatures that are all the more monstrous because of their resemblance to ordinary human beings.

A Secret Obsession

Inspired by *Jigoku Sensei Nūbū* and other manga publications, Isayama began drawing manga art. He sensed that his parents would find his dark, brooding drawings to be disturbing, so he hid his artwork. One day, however, Isayama left some drawings out on his desk, and his father happened to see them. Worried that his son's interest in manga might hurt his studies and lead him toward a career in which there is little chance of success, Mitsuo Isayma told his son he could not become a manga artist.

Isayama was not deterred. He continued to draw in secret, but that was not because he was confident in his abilities. On the contrary, he was filled with doubt. "Since elementary school, I dreamed of being a mangaka but I wasn't exceptional," he says. "In my class, there were two or three friends who had already started making their own manga. At that time, I hadn't started my manga, but I dreamed of becoming a mangaka."[23]

After graduating from Hita Rinko Senior High School, Isayama enrolled at Kyushu Designer Gakuin, a vocational design school. The school offers several practical majors, including fashion design, graphic design, and video game design. But it also offers courses in manga art. Isayama promised his parents that he would study one of the practical arts, but he secretly enrolled in the manga courses.

Encouragement from Afar

While in college, Isayama began to work on his story about bloodthirsty giants and the brave young man who opposes them. At age nineteen, Isayama entered a short version of *Attack on Titan* entitled "Heart Break One" in the 80th Weekly Shōnen Magazine Freshman Manga Awards sponsored by the manga publisher Kodansha. The

judges were impressed with the newcomer's work. They presented Isayama with the Special Encouragement Award.

When Isayama told his parents about his success, they were pleased, but they found his award-winning drawings disturbing. "At first I considered it grotesque," says his father. "I made a little suggestion to him: 'Aren't there some options such as baseball manga or soccer manga?'" Mitsuo Isayama was still concerned about his son's future. "I thought the probability of success [for being a manga artist] would be very low. . . . I had a feeling that it would be good for him to just take a normal job."[24] Isayama's mother was more encouraging. She told him to go ahead and give his manga career his full effort. If it did not work out, he could move on to something else.

Isayama took his mother's advice. After graduating from Kyushu Designer Gakuin, Isayama moved to Tokyo to look for a publisher. He took a part-time job in an internet café and began to make the rounds with his portfolio. The editors liked Isayama's story line, but they felt that the quality of his drawings was poor. Isayama wondered whether he was wasting his time. His last appointment was with Kodansha, the publishing house that had given him the Special Encouragement Award. Like the editors at the other publishing houses, Kodansha editor Kawakubo Shintaro found Isayama's story line intriguing. Unlike the others, however, Shintaro was impressed with the young artist's artwork. Isayama was dumbfounded. "My self esteem was so low that when my editor said he liked it, I remember thinking: 'What's wrong with this guy?'"[25]

> "My self esteem was so low that when my editor said he liked it, I remember thinking: 'What's wrong with this guy?'"[25]
>
> —Hajime Isayama

Breakthrough

Shintaro offered Isayama a contract to serialize *Attack on Titan* in the company's monthly *Bessatsu Shōnen Magazine*. The series

Improvising Stories

Isayama was a storyteller from an early age, but he did not tell his first stories with drawings. He told them with dolls. Those childhood stories were largely improvised, using the dolls at hand. Isayama says he continued to use spur-of-the-moment inspiration when creating *Attack on Titan*:

> I've always felt there's a feeling inside me that can't be taught to others. I think that feeling is really suited to drawing manga, and I've come to think about it as I've continued with the series. Until I was in the upper grades of elementary school, I used to play with dolls with my friends. And when we played with dolls, we would improvise stories as we went along. Since then, I often found that the improvised stories were connected to the previous ones by chance. . . .
>
> The main part of the story and the story of [*Attack on Titan* characters] Eren, Mikasa and Armin were decided beforehand. But the details of the story and the actions of the other characters were decided as the series progressed. At that time, the materials to build the story began to walk on their own.

Quoted in Attack On Fans (@AttackOnFans), "But as the series continued, didn't that unfounded trust turn into confidence . . . ?," Twitter, June 6, 2021. https://twitter.com/AttackOnFans/status/1402394636627423240.

debuted in September 2009 and quickly gained a loyal following. But success did not bring Isayama immediate happiness. He did not have any friends in Tokyo, and he suffered from loneliness and insecurity. "The first stage of my career was a struggle against loneliness," he says. "Even though the manga I was drawing was popular and I was making enough money to live on, I still had a complex in my mind that I was not a good person. . . . When I'm walking down the street in the middle of the night, there are times when I feel inferior, like I am a useless, helpless, lonely creature."[26]

Although some critics consider Isayama's drawings to be somewhat crude, others believe his simple, forceful style suits his subject matter. "This is a manga that strongly evokes the primitive fears of humans in the form of gigantic things that are approaching," writes critic Tomofusa Kure. "If [the manga were] presented with refined illustrations, this eeriness wouldn't have been possible."[27]

> "This is a manga that strongly evokes the primitive fears of humans in the form of gigantic things that are approaching. If [the manga were] presented with refined illustrations, this eeriness wouldn't have been possible."[27]
>
> —Tomofusa Kure, media critic

In 2011 *Attack on Titan* won the 35th Kodansha Manga Award for Best *Shōnen* Manga—the first of fifteen awards the series would receive over the next four years. *Attack on Titan* went on to be recognized for its excellence worldwide, garnering awards in Japan, France, Spain, Italy, the United Kingdom, and the United States. The series ran in *Bessatsu Shōnen Magazine* for eleven and a half years, through April 2021. Its chapters have been collected into thirty-four books that have sold more than 100 million copies worldwide.

A Television Hit

The popular manga series caught the attention of the newly formed Japanese animation company Wit Studio. The studio offered Isayama a deal to bring his story to television. A weekly series based on the nightmarish tale debuted on April 7, 2013. The series was directed by Tetsurō Araki, a Japanese animator, storyboard artist, and director who had already directed five television series. The anime version of *Attack on Titan* was a ratings hit. It also impressed the critics. At the end of the program's first year, it received the Grand Prize (Animated Comic) at the 6th Bros Comic Awards in Japan.

Losing Self-Confidence

After completing the *Attack on Titan* series for *Bessatsu Shōnen Magazine*, Hajime Isayama sat down with manga artist Hiromu Arakawa, creator of *Fullmetal Alchemist*, to answer questions about his career for the series guidebook *Attack on Titan Character Encyclopedia FINAL*. In this excerpt, Isayama discusses the confidence he had in his work as a student, how he lost that confidence, and how he regained it:

> When I was in high school, I had a kind of unfounded love in my eyes, and although no one appreciated my work, I thought I was a genius. But when I started attending a vocational school, I met a lot of people who were better than me. I realized that I wasn't as good as ordinary people, and that unfounded trust was completely shattered. But when I met [Kodansha editor Kawakubo Shintaro], and before *Attack on Titan* was published in series, I was selected for the Weekly Shonen Magazine's Breakthrough Manga Award, which made me think: "Oh, my ego wasn't wrong!" I've been able to continue to be proud of myself!

Quoted in Attack On Fans (@AttackOnFans), "The 'Sense' That Helped Me as a Mangaka After 11 and a Half Years of Work," Twitter, June 8, 2021. https://twitter.com/AttackOnFans/status/1402394569711435778.

Wit Studio brought in Masashi Koizuka, an animation concept designer best known for his work on the anime television series *Reservoir Chronicle: Tsubasa*, to direct a second season, which aired in 2017. A third season, also directed by Koizuka, aired from 2018 to 2019. Isayama enjoyed seeing his drawings come to life. "It was interesting to see how the director and voice actors took the characters out of my hands in a good way, and made them start to move as independent 'lives' for the first time."[28]

In September 2020 a new director, Jun Shishido, began work on the final season of *Attack on Titan*. Shishido is best known for directing the anime series *Hajime no Ippo: Rising*. Because of the

COVID-19 pandemic, the fourth season was broken into two parts. The first part began airing in December 2020 in Japan and in January 2021 in the United States with episode number sixty, "The Other Side of the Sea." Fifteen more episodes followed, ending with episode seventy-five, "Above and Below," which aired in March 2021 in Japan and in May 2021 in the United States. The second part of the fourth season was scheduled to begin airing in late 2021.

Plagued by Doubts

As the anime series gained a worldwide following, Isayama worked toward the completion of the *Attack on Titan* manga story. Isayama brought the manga series to a close after eleven years with Chapter 139, which was released in *Bessatsu Shōnen Magazine* on April 9, 2021. Almost immediately, however, Isayama expressed dissatisfaction with the ending. In an interview with Hiromu Arakawa, creator of the *Fullmetal Alchemist* series, for the final guidebook of the series, Isayama apologized to his readers for the way the series ended:

> In the last part of the story, I realized that the theme was too difficult for me to draw, and I really regret that I couldn't express it in my drawings properly. After eleven and a half years of work, when I finished my last manuscript, I really thought that I would be able to make everyone happy, but I think I was overconfident. I'm sorry for those of you who supported me. I let you down in the end.[29]

Many of Isayama's fans feel the artist sold himself short. "Finished the leak of chapter 139 of Attack On Titan and all I got to say is #ThankYouIsayama for the hell of a ride," wrote one fan on Twitter. "Eren Jeager is the best MC [main character] of anything I have ever read and watched, lastly 'To the boy who sought freedom . . . GOODBYE.'"[30] Another fan agreed. "I read the ending and was unsure and kinda unhappy about it, but af-

ter I thought on it much more it all clicked," the fan said. "I know at face value it can all seem a bit wonky, but I now think this ending is AMAZING."[31]

Striving for Perfection

Hopeful that he could improve on the ending, Isayama announced that he would try to create a better ending in the final volume of the book series. In *Bessatsu Shōnen Magazine*, Isayama was limited to fifty-one pages, but the book had fifty-nine pages to work with. His plan was to use the eight extra pages to tie up loose ends and create a more satisfying conclusion, including new panels for the ending.

The last *Attack on Titan* book, volume 34, went on sale in Japan in June 2021. The release of the final English book

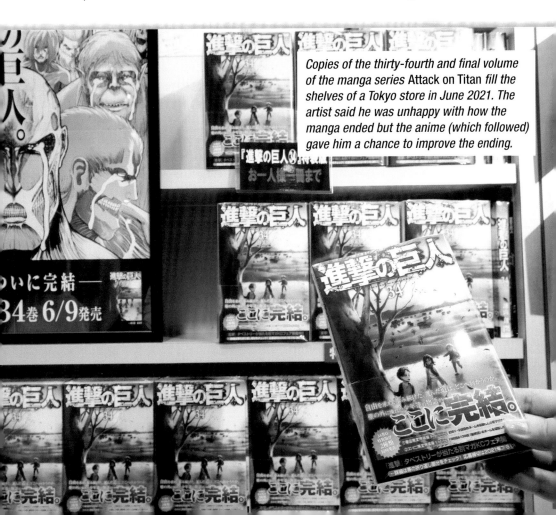

Copies of the thirty-fourth and final volume of the manga series Attack on Titan *fill the shelves of a Tokyo store in June 2021. The artist said he was unhappy with how the manga ended but the anime (which followed) gave him a chance to improve the ending.*

was slated for October 2021, just ahead of part 2 of the fourth television season. The manga series included twenty-three chapters after "Above and Below," the last anime episode to air. With each animated episode covering one or two manga chapters, part 2 of the final season of *Attack on Titan* is expected to include sixteen to twenty-three episodes, and possibly more.

The production of the final episodes of the *Attack on Titan* anime will trail the conclusion of the manga series by several months. This gives Isayama the opportunity to further improve on his ending, if he wants to. He has done this throughout the four seasons of the anime. "For me, manga is like a live show and anime is the record," Isayama explains. "In the manga, there are some parts I've messed up, but the anime version made up for them and perfected *Attack on Titan*. For me, the anime is original [and] completes *Attack on Titan*."[32] Millions of anime fans around the world hope that the magic of anime works one more time and Isayama is able to put the finishing touches on *Attack on Titan* that will leave him feeling satisfied with his masterpiece.

Chapter Four

Akira Toriyama

Born April 5, 1955, in Nagoya, Japan, Akira Toriyama had a startling revelation when he was in elementary school. For some reason, the pictures he drew for art class were more realistic than those of his peers. "My earliest memory of having done a drawing 'right' is that of a horse," he recalls. "I still remember it. I felt that 'the joints were drawn well.'"[33]

Popular Prodigy

Toriyama soon found he could draw other things well, too. "We all copied manga and anime drawings," he recalls. "Eventually, I began drawing original pictures of my friends' faces, and it was then that I began to feel that 'drawing pictures is fun.'"[34] Adults recognized Toriyama's talent as well. While still in elementary school, he won a prize from a local art school for a picture he drew from the Walt Disney movie *101 Dalmatians*.

After elementary school, Toriyama stopped reading manga, but he remained serious about art, drawing and painting all through middle school and high

Akira Toriyama began drawing as a child. While still in elementary school, he won a prize from a local art school for a picture he drew from the Walt Disney movie 101 Dalmatians.

school. After graduating from high school, Toriyama got a job as an illustrator in a graphic design studio. Although he was earning good money, he was bored by the repetitive nature of his work. He remembers complaining, "Ugghh. . . . Why do I have to draw one hundred pairs of socks?!"[35]

A Return to Manga

Toriyama eventually quit his job in the design studio. With no income, he once again depended on his parents for support—a fact that he found embarrassing. One day he read about an amateur contest in the weekly manga magazine *Jump*. Hoping to win the cash prize, he entered some of his drawings. He did not win, but one of the editors, Kazuhiko Torishima, recognized his drawing ability and encouraged him to continue submitting his work.

Toriyama did so, and Torishima eventually accepted a story titled *Wonder Island*. It ran in *Weekly Shōnen Jump* in 1978. Toriyama was thrilled, but the story was not embraced by fans. The magazine had a survey form in the front that asked readers to circle the stories they liked and send it in. *Wonder Island* came in last in the voting. Nevertheless, Torishima told the young artist to keep trying.

Toriyama did just that, filling at least five hundred blank pages with manga drawings, many of which he sent to Torishima. After a year of nothing but rejections, Toriyama drew a story about a mad scientist who creates a young-looking female android. Torishima saw potential in it. He wrote back, suggesting that Toriyama make the little robot the main character.

Creating a Popular Character

Toriyama took his editor's advice and began to work on the character, Arale Norimaki. He gave her features that would make her unique, endearing, and comical. For example, he gave her superhuman strength and speed, which is surprising for a pint-sized android. He also made her nearsighted. As a result, she was the first robot to wear glasses, a fact that makes her appealing to many readers, especially eyeglass wearers. With a computer for a brain, Arale can solve math problems in a nanosecond, but she lacks common sense. She often misunderstands what people mean, a fact that serves as launching pad for many of her humorous misadventures. Oddly, Arale is fascinated by human feces, perhaps because robots do not defecate. She often pokes at piles of poop with a stick or even speaks to it. Arale's odd interest eventually led to the creation of a pile of poo who responds to her named Poop Boy. Toriyama's Poop Boy is credited with inspiring the Pile of Poo emoji, which began to appear in Japanese cell phones in the 1990s and is now on almost all social media platforms.

The story about Arale became *Dr. Slump*, and Torishima loved it. He agreed to publish it, and it debuted in *Weekly Shōnen Jump* in February 1980. The blend of action, adventure, and quirky humor clicked with readers. *Dr. Slump* built a loyal following, and in 1981 it received the Shogakukan Manga Award for best *shōnen* or *shōjo* manga series of the year. The series ran from 1980 to 1984, and the chapters were published in eighteen volumes. The first volume alone sold 1.9 million copies. More than 35 million copies have been sold worldwide.

Moving to the Small Screen

The success of the manga caught the attention of Fuji Television and Tōei Animation. The companies adapted *Dr. Slump* into a television series that ran for 243 episodes, from 1981 to 1986. Millions of viewers in Japan flocked to the adventures of the intrepid little android and the cast of characters who surround her in her hometown, Penguin Village. When the program debuted in 1981, almost 37 percent of the viewing public tuned in. It was the third-highest percentage of viewers that an anime program had ever had. The program had a distinct impact on Japanese culture. Arale's greeting, "N'cha," was adopted by millions of fans. For a joke, many fans also mimicked Arale's style of running, with her arms outstretched like airplane wings and making airplane noises.

Critics loved the series, too. Michael Toole of Anime News Network writes:

> "Akira Toriyama's whimsical tale of the world's lousiest scientist and his robot 'daughter' . . . is one of those things that's so jam-packed with jokes that it's hard to remember which one you started laughing at."[36]
>
> —Michael Toole, anime critic

I figure that any TV show that co-stars a talking pile of poop is a good one, and Dr. Slump has that base covered. Akira Toriyama's whimsical tale of the world's lousiest scientist and his robot "daughter" . . . is one of those things that's so jam-packed with jokes that it's hard to remember which one you started laughing at. I consider the comics to be the greatest manga of all time, and the anime's no slouch, either—it's jammed with the kind of parody, gags, and fart jokes that everyone from toddlers to grandparents can enjoy together.[36]

Toriyama's Fighting Spirit

After Akira Toriyama's manga *Wonder Island* failed to find an audience, the twenty-three-year-old artist continued to submit new ideas and sketches to his editor, Kazuhiko Torishima. Torishima rejected Toriyama's submissions one after another, often with harsh words. Toriyama told Tetsuko Kuroyanagi, the host of the Japanese television program *Tetsuko's Room*, how Torishima's tough treatment served as inspiration: "When I'd draw something and send it, he'd say things like, 'This is no good; it's not interesting at all. Why don't you draw something more interesting.' I am the kind of person who really doesn't like to lose, so I'd repeat the cycle of him telling me it wasn't interesting and me getting ticked off, drawing again, and sending it in."

Toriyama's persistence paid off. After a year of rejections, Toriyama submitted a story about a mad scientist who creates a cute android. Torishima encouraged Toriyama to develop a story about these characters, and that story became Toriyama's first hit, *Dr. Slump*.

Quoted in brolyssj, *Akira Toriyama Interview (Translated)—Tetsuko's Room*, YouTube, May 18, 2020. https://youtu.be/oVuwrWn-k-c.

Big Screen Success

At the same time Tōei Animation was producing the television series, it began work on a movie based on an episode in the manga in which Senbei Norimaki, the maker of Arale, travels to Wonder Island to obtain an ingredient for a love potion he is making. The film, *Hello! Wonder Island*, debuted in 1981. A popular success, it was followed by nine more *Dr. Slump* movies, including *Hoyoyo! Space Adventure* (1982), *Dr. Slump and Arale-chan: Hoyoyo! The City of Dreams, Mechapolis* (1985), and *Arale's Surprise Burn* (1999).

Toriyama was surprised by the success of *Dr. Slump*. Thinking it would last only a few months, he never had a plan for the series. He just made it up as he went along, often beginning a weekly installment without knowing how it would end. He thrived

under the pressure of coming up with plot twists and jokes, but after about six months, he was already thinking about ending the series. Torishima told him that he could only leave the series after he had come up with a new one to replace it.

A Change of Direction

Tired of the gag series, Toriyama wanted to try something that would appeal to older audiences. He was a fan of martial arts movies, especially those of actor-directors Bruce Lee and Jackie Chan. He revered Lee for his explosive fighting style, and he admired Chan for the way he peppers his fight scenes with stunts and unexpected pauses for comic effect. Toriyama began to imagine a martial arts manga that also would blend action and humor. Torishima liked the idea as well.

While still working on *Dr. Slump*, Toriyama created a two-part story titled *Dragon Boy*. It tells the story of a martial arts prodigy who meets a teenage princess and helps her on her journey back to her father's kingdom. Pleased with the story, Torishima accepted it for publication, running it in the August and October 1983 issues of the monthly manga magazine *Fresh Jump*. Readers rated the new story highly, and Toriyama decided to develop it into a series.

Rather than plunge ahead with no structure in mind, as he did with *Dr. Slump*, Toriyama based the new series on the sixteenth-century Chinese novel *Journey to the West*, an adventure story in which a Chinese man travels to India to retrieve certain Buddhist scriptures from a temple that is high in the mountains. Along the way, the main character, Tang Sanzang, encounters various evil characters and challenges.

Toriyama married this concept to a story line of the nineteenth-century Japanese novel *The Chronicles of the Eight Dog Heroes of the Satomi Clan of Nanso*. That novel tells the story of a character named Daisuke, who takes the form of a Buddhist priest and sets out to collect eight sacred prayer beads. In Toriyama's version, a monkey-tailed boy named Goku meets a teenage girl

Inspired by the explosive fighting style of Bruce Lee and the stunts and comic pauses of Jackie Chan (pictured in a scene from the 2008 film Forbidden Kingdom*), Toriyama began to imagine a martial arts manga that would blend action and humor.*

named Bulma, who convinces him to join her quest to collect seven balls that can be used to summon a wish-granting dragon. Toriyama called the orbs Dragon Balls and named the manga series after them: *Dragon Ball*.

Fighting Against Failure

After four years, at the height of *Dr. Slump*'s popularity, Toriyama brought the series to an end. His new series, *Dragon Ball*, debuted in *Weekly Shōnen Jump* in 1984. It was a modest hit, but its popularity waned.

Toriyama's editor demanded changes to save the series. "Torishima-san was really on my case about it, saying 'nobody likes it!' and mean stuff like that," says Toriyama. "From the start I had thought in the back of my mind that since it was a *shōnen* [boys] manga it would be better received if I drew battles, but because I'm perverse I kept sticking with *Journey to the West*." Then Toriyama invented a World Martial Arts Tournament for his characters.

The manga's popularity ticked up, and Toriyama again thought about including more fight scenes. "I tried to fight it," he remembers. "I had Arale-chan make an appearance, and made things comical, and it felt like a struggle. But in the end, I couldn't even satisfy myself, so I decided to bite the bullet and make it all about the fighting."[37]

From there the series took off, on its way to becoming one of the most popular manga series of all time. According to the Japanese business website exlight.net, the circulation of *Weekly Shōnen Jump* rose from about 4.5 million copies a week when *Dragon Ball* debuted to a high of 6.53 million per week when the series ended in 1995. Over that eleven-year period, nearly 3 billion copies of the magazine were sold. After *Dragon Ball* ended, weekly subscriptions to *Weekly Shōnen Jump* plunged to about 3.5 million copies a week. Meanwhile, the weekly installments of *Dragon Ball* were collected into forty-two *tankōbon* volumes, which have sold about 300 million copies worldwide.

Constant Innovation

To keep the series fresh, Toriyama allowed Goku to age from a child to a teen and then to an adult. As Goku aged, Toriyama drew him differently. He became taller and leaner—a change that made the fighting scenes more realistic and exciting.

Toriyama also introduced new abilities into his characters that they did not know they had, such as the ability to transform into a more powerful self. Toriyama says such changes were not planned. "It all started with [the character] Freeza," he explains. "I didn't start out with any plans to have him transform, but midway through I thought it might be cool to make it look like a bluff and then have him transform for real."[38] Toriyama then allowed his characters' foes to transform as well, creating even more epic battles.

Toriyama Gets His Way

To depict Goku, the main character of *Dragon Ball*, as an adult, Akira Toriyama decided to change his hero's body from short and squat to tall and lean. Toriyama later revealed how his editors objected to his decision and how he overcame their objections:

> I got a lot of pushback on that at the time. Apparently in *shōnen* manga, changing what the main character looked like was a big no-no, but I didn't care about that. His head/body ratio made fighting hard, so I said that if the series was going to start focusing more on battles, then I needed to make him an adult. But this really shocked them: "The series has finally gotten popular, and now you want to go and change everything!" That was the kind of reaction I got. . . .
>
> I drew a sketch of adult Goku and sent it over to the editorial office to get their feedback. But then I started drawing the rough draft before I even heard back from them. By the time I sent the rough draft to the editorial office, there wasn't any time left to make major revisions, so they were just like "if you're so dead-set on doing this, then fine."

Quoted in Kanzenshuu, "Akira Toriyama Interview: *Dragon Ball* and Akira Toriyama," January 21, 2016. www.kanzenshuu.com.

A New Anime Series

As the *Dragon Ball* manga gained momentum, Shueisha, the publisher of *Weekly Shōnen Jump*, again teamed up with Tōei Animation to produce a television series based on Toriyama's work. This time, Toriyama, who did not think the *Dr. Slump* anime was as good as it could have been, decided to do things differently. He created a massive book of guidelines, outlining what characters could and could not do, how their different properties worked, and other details about how they should be depicted. Toriyama also had a hand in casting the voice actors for the major roles.

Animation benefited *Dragon Ball*. The fight scenes were enhanced by motion and sound. Effects like transformations and fusions were brought to life in ways that the still drawings of the manga could never convey. The action-packed program, which still included Toriyama's trademark humor, was a hit in Japan and around the world. *Dragon Ball* ran from 1986 to 1989, and its sequel, *Dragon Ball Z*, ran from 1989 to 1996.

Global Impact

Tōei also produced seventeen *Dragon Ball* movies for theatrical release—three based on the original *Dragon Ball* series and fourteen based on *Dragon Ball Z*. Less than an hour long, these movies were paired with other Tōei Animation films when shown in Japan. With 50 million tickets sold and grossing half a billion dollars, the first sixteen movies were the highest-grossing anime series up to that time. In 1996 Tōei released *Dragon Ball: The Path to Power*, a full-length movie to commemorate the tenth anniversary of the series. The movie earned $13 million at the box office in Japan. It was the last of the movie series until a revival in 2013 and the last to use cel animation.

The television series was broadcast in eighty-one countries worldwide. The US version was produced by Funimation, a California company that specializes in dubbing and distributing East Asian material for American audiences. Although the first thirteen-episode series was canceled for low ratings in 1995, a reboot ran on the Cartoon Network from 2001 to 2003. The series blazed a trail for anime in the West. "Goku's adventures were the first of their kind to have a measurable impact on western networks and exposed a generation of youngsters to an entirely new art form,"[39] writes television critic Craig Elvy.

> "Goku's adventures were the first of their kind to have a measurable impact on western networks and exposed a generation of youngsters to an entirely new art form."[39]
>
> —Craig Elvy, television critic

Toriyama teamed up with screenwriter Yūsuke Watanabe to write Dragon Ball Z: Battle of Gods *(pictured), the first* Dragon Ball *movie in seventeen years and the first to use digital ink and paint.*

Dragon Ball Redux

In 2015 Toriyama teamed up with manga artist Toyotarou to launch *Dragon Ball Super*, a weekly series that is still running in *V Jump*, a Japanese magazine devoted to new manga and video games based on manga. The story, created by Toriyama, covers ten years missing from the original *Dragon Ball* chronology, years when Goku learns to use his newly discovered godlike powers. Toriyama draws certain key scenes, while Toyotarou illustrates the bulk of the series. More than 3 million copies of *Dragon Ball Super* collections had been sold in Japan by 2021. NPD, an American market research company, reported that volume 4 of *Dragon Ball Super* was the best-selling graphic novel in the United States in January 2019.

Toriyama also worked with Tōei Animation to revive the *Dragon Ball* movie series in the 2010s. He teamed up with screenwriter Yūsuke Watanabe to write *Dragon Ball Z: Battle of Gods*,

the first *Dragon Ball* movie in seventeen years and the first to use digital ink and paint. Released in 2013, *Dragon Ball Z: Battle of Gods* tells the story of a confrontation between Goku and Beerus, the God of Destruction. Despite the long lapse between *Dragon Ball* movies, *Dragon Ball Z: Battle of Gods* became the most successful *Dragon Ball* movie up to that time, earning $32 million in Japan and more than $20 million in other countries.

Toriyama also wrote the next three movies in the series: *Dragon Ball Z: Resurrection 'F'* (2015), *Dragon Ball Super: Broly* (2018), and *Dragon Ball Super: Super Hero*, which was scheduled for release in 2022. *Dragon Ball Super: Broly* became the highest-grossing *Dragon Ball* movie and the twelfth-highest-grossing anime film of all time, grossing more than $100 million worldwide.

The enduring allure of Toriyama's *Dragon Ball* universe has astounded media experts. "Surprisingly . . . , Dragon Ball has only surged in popularity over more recent years, despite the end of the main series and long periods of inactivity," writes Elvy. "Dragon Ball is the unrivaled benchmark for anime success on an international level."[40]

Source Notes

Introduction: Global Phenomenon

1. Quoted in Julianne Sun, "Anime Might Not Be Cool, but It's Definitely Getting Popular," *North by Northwestern*, April 19, 2021. https://northbynorthwestern.com.

Chapter One: Osamu Tezuka

2. Quoted in Frederik L. Schodt, *Astro Boy Essays*. Berkeley, CA: Stone Bridge, 2006, p. 20.
3. Quoted in Schodt, *Astro Boy Essays*, p. 21.
4. Quoted in Schodt, *Astro Boy Essays*, p. 66.
5. Quoted in Schodt, *Astro Boy Essays*, p. 80.
6. Quoted in Schodt, *Astro Boy Essays*, p. 166.

Chapter Two: Hayao Miyazaki

7. Quoted in Susan Napier, *Miyazakiworld*. New Haven, CT: Yale University Press, 2018, p. 12.
8. Quoted in Napier, *Miyazakiworld*, p. 13.
9. Quoted in Jeff Lenberg, *Hayao Miyazaki*. New York: Chelsea House, 2012, p. 14.
10. Hayao Miyazaki, *Starting Point*, trans. Frederik L. Schodt and Beth Cary. San Francisco: VIZ Media, 2009, pp. 96–97.
11. Miyazaki, *Starting Point*, p. 70.
12. Quoted in Napier, *Miyazakiworld*, p. 33.
13. Quoted in Napier, *Miyazakiworld*, p. 38.
14. Quoted in Mark Schilling, *The Encyclopedia of Japanese Pop Culture*. New York: Weatherhill, p. 140.
15. Quoted in Lenberg, *Hayao Miyazaki*, p. 31.
16. Miyazaki, *Starting Point*, p. 50.
17. Quoted in Arakawa Kaku, director, *Never-Ending Man: Hayao Miyazaki*, trans. David Crandall. Tokyo: NHK, 2017.

Chapter Three: Hajime Isayama

18. Quoted in Mona, "Who's Hajime Isayama? Here's Why *Attack on Titan* Became One of the Best Manga," Otashift, June 25, 2019. www.otashift-tokyo.com.
19. Quoted in BBC News, *Manga Artist Hajime Isayama Reveals His Inspiration*, YouTube, October 19, 2015. https://youtu.be/lD DRtjSq3Fc.
20. Quoted in Mona, "Who's Hajime Isayama?"
21. Quoted in BBC News, *Manga Artist Hajime Isayama Reveals His Inspiration*.
22. Quoted in Mona, "Who's Hajime Isayama?"
23. Quoted in Mona, "Who's Hajime Isayama?"
24. Quoted in Suniuz, "Thanks to the anon who brought this old news to my attention," Tumbler, January 20, 2018. https://suniuz.tumblr .com/post/169934705896/thanks-to-the-anon-who-brought-this -old-news-to-my.
25. Quoted in BBC News, *Manga Artist Hajime Isayama Reveals His Inspiration*.
26. Quoted in Attack On Fans (@AttackOnFans), "Didn't you find it difficult not to get carried away by it?," Twitter, June 9, 2021. https:// twitter.com/AttackOnFans/status/1402658649927999489.
27. Quoted in Atsuhi Ohara and Yukiko Yamane, "Boosted by Anime Version, 'Attack on Titan' Manga Sales Top 22 Million," *Asahi Shimbun*, August 17, 2013. https://web.archive.org.
28. Quoted in Attack On Fans (@AttackOnFans), "As for the memories of the work itself, isn't the TV anime adaptation a big memory?," Twitter, June 9, 2021. https://twitter.com/AttackOnFans/status /1402658801128464388.
29. Quoted in Attack On Fans (@AttackOnFans), "Eren's Actions Are the Worst Way to Act," Twitter, June 9, 2021. https://twitter.com /AttackOnFans/status/1402658987703689220.
30. Aesthetic (@Aesthetic_XXV), "Finished the leak of chapter 139 of Attack on Titan and all I got to say is #ThankYouIsayama for the hell of a ride," Twitter, June 7, 2021. https://twitter.com/Aesthetic_XXV /status/1379968999564267521.
31. Quoted in 9GAG, "Fans Are Divided over the Ending of 'Attack on Titan' Manga," April 8, 2021. https://9gag.com.
32. Quoted in Mona, "Who's Hajime Isayama?"

Chapter Four: Akira Toriyama

33. Quoted in Nobu Taguchi, trans. "Toriyama Akira Super Interview," *Coffee Table Books Vol. 6, Daizenshuu: Movies & TV Specials*, October 15, 1995. http://tsoj.manga.org/db/tori_bk6.html.

34. Quoted in Taguchi, "Toriyama Akira Super Interview."

35. Quoted in Taguchi, "Toriyama Akira Super Interview."

36. Michael Toole, "The Anime Alphabet," Anime News Network, February 22, 2015. www.animenewsnetwork.com.

37. Quoted in Kanzenshuu, "Akira Toriyama Interview: *Dragon Ball* and Akira Toriyama," January 21, 2016. www.kanzenshuu.com.

38. Quoted in Kanzenshuu, "Akira Toriyama Interview."

39. Craig Elvy, "No Other Anime Will Ever Emulate *Dragon Ball*'s Success," Screen Rant, February 13, 2020. https://screenrant.com.

40. Elvy, "No Other Anime Will Ever Emulate *Dragon Ball*'s Success."

For Further Research

Books

Toshio Ban, *The Osamu Tezuka Story: A Life in Manga and Anime*, trans. Frederik L. Schodt. Berkeley, CA: Stone Bridge, 2016.

Raz Greenberg, *Hayao Miyazaki: Exploring the Early Work of Japan's Greatest Animator*. New York: Bloomsbury Academic, 2018.

Robert Henderson, *Quick Guide to Anime and Manga*. San Diego, CA: ReferencePoint, 2022.

Rémi Lopez, *The Impact of Akira: A Manga (R)Evolution*. Toulouse, France: Third Editions, 2021.

Frenchy Lunning, ed., *Tezuka's Manga Life*. Minneapolis, MN: University of Minnesota Press, 2013.

Helen McCarthy, *The Art of Osamu Tezuka: God of Manga*. New York: Abrams, 2009.

Hayao Miyazaki, *Starting Point*, trans. Frederik L. Schodt and Beth Cary. San Francisco: VIZ Media, 2009.

Hayao Miyazaki, *Turning Point*, trans. Frederik L. Schodt and Beth Cary. San Francisco: VIZ Media, 2014.

Susan Napier, *Miyazakiworld*. New Haven, CT: Yale University Press, 2018.

Rikao Yanagita, *The Science of "Attack on Titan."* New York: Kodansha Comics, 2015.

DVD

Arakawa Kaku, director, *Never-Ending Man: Hayao Miyazaki*, trans. David Crandall. Tokyo: NHK, 2017.

Internet Sources

Craig Elvy, "No Other Anime Will Ever Emulate *Dragon Ball*'s Success," Screen Rant, February 13, 2020. https://screenrant.com.

Will Heath, "20 Best Female Manga Artists You Need to Know," Japan Objects, October 9, 2020. https://japanobjects.com.

Juha, "World's Best Anime and Manga Artists Ever," Okuha, March 13, 2020. https://okuha.com.

Kanzenshuu, "Akira Toriyama Interview: *Dragon Ball* and Akira Toriyama," January 21, 2016. www.kanzenshuu.com.

Mona, "Who's Hajime Isayama? Here's Why *Attack on Titan* Became One of the Best Manga," Otashift, June 25, 2019. www.otashift-tokyo.com.

Susana Polo, "Does Hayao Miyazaki Hate the Father of Manga?," Polygon, May 27, 2020. www.polygon.com.

Cheryl Teh, "It's Been 20 Years Since the Oscar-Winning Animated Movie 'Spirited Away' Was Released. Here Are 5 Ways It Changed Japanese Animation Forever," Insider, July 21, 2021. www.insider.com.

Yusuke-s, "30 Best Anime of All Time (2021)," Japan Web Magazine, August 4, 2021. https://jw-webmagazine.com.

Websites

Anime News Network
www.animenewsnetwork.com
News, reviews, and feature reports on anime, manga, video games, and brief bios of manga and anime artists.

Dragon Ball Official Site
https://en.dragon-ball-official.com
Headquarters for all things *Dragon Ball*—news, product information, events, videos. Includes a video newscast in Japanese with English subtitles covering *Dragon Ball* events of the week.

Studio Ghibli
www.ghibli.jp
The official website of the animation studio founded by Hayao Miyazaki. Includes information about new releases, stage productions, exhibitions, and upcoming events. Also includes a large library of colorful stills from the studio's animated classics, including *Spirited Away*.

Tezuka Osamu Official Website
www.tezukaosamu.net
A collection of all things Tezuka, including a profile, a timeline of his life, photo albums, an animated short about his life (in Japanese only), and the wisdom he wanted to pass on to future generations in his "Message for Earth."

T.H.E.M. Anime Reviews
www.themanime.org
This website offers up-to-date reviews of anime in all forms, including movies, television, and direct-to-video releases. Includes a huge, searchable archive of past reviews, arranged in alphabetical order by title. Also hosts message boards on a wide range of topics.

Index

Picture Credits